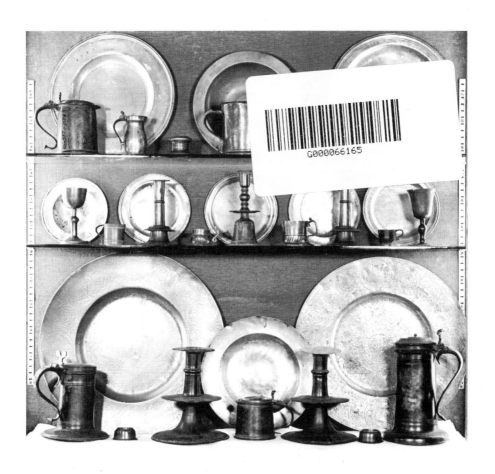

A display of mainly seventeenth-century English pewter.

PEWTER

Charles Hull

Shire Publications Ltd

CONTENTS

Published in 2005 by Shire Publications Ltd, Cromwell House, Church Street, Princes Risborough, Buckinghamshire HP27 9AA, UK. Website: www.shirebooks.co.uk Copyright © 1992 by Charles Hull. First published 1992, reprinted 1996, 1999 and 2005. Shire Album 280. ISBN 0 7478 0152 5.

Printed in Great Britain by CIT Printing Services Ltd, Press Buildings, Merlins Bridge, Haverfordwest, Pembrokeshire SA61 1XF.

British Library Cataloguing in Publication Data: Hull, Charles. Pewter. — (Shire Albums series; No. 280). I. Title. I. Series. 739.5. ISBN 0-7478-0152-5.

ACKNOWLEDGEMENTS
The author expresses his thanks for advice and assistance to the manufacturers in the Association of British Pewter Craftsmen; members of the Pewter Society, the acknowledged authority on antique British pewter; and above all to the Worshipful Company of Pewterers for making available their unique reference collection of British pewter and providing the majority of the illustrations.

Illustrations are acknowledged as follows: American Museum in Britain, Bath, page 32; Ashmolean Museum, Oxford, page 3 (left); Birmingham City Museum and Art Gallery, page 5 (left); Edwin Blyde, page 20 (left); Cambridge Museum of Archaeology and Ethnology, page 3 (right); I. Gibson and Son, page 20 (right); Museum of London, pages 5 (centre and right) and 9 (lower right); Trustees of the British Museum, page 14 (bottom two); Victoria and Albert Museum, pages 23 (top) and 24 (right); Dr and Mrs Melvin D. Wolf, page 25 (top); Worshipful Company of Pewterers, pages 1, 2, 6 (bottom), 7 (both), 8, 9 (all except lower right), 10-13 (all), 14 (top), 15 (both), 17 (all), 18 (bottom), 19 (all), 20 (centre), 21 (all), 22 and 23 (bottom). The illustrations on page 16 are from the author's collection and that on page 6 (top) is from a private collection.

Cover: Half-gallon Cromwellian flagon, c.1655, by Robert Martin, Master of the Worshipful Company of Pewterers in 1674, in the Chichester Cathedral Treasury. Note the accentuated flared base, which is a feature of some flagon designs of the period.

Below: A set of baluster-shaped wine measures from 1 gallon to ¹/₂ gill, c.1730-80. Baluster measures were made from c.1500 to 1826 (when imperial measures were introduced) and can be dated mainly from the shape of the body, the types of handle and thumbpiece.

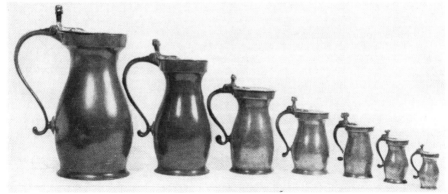

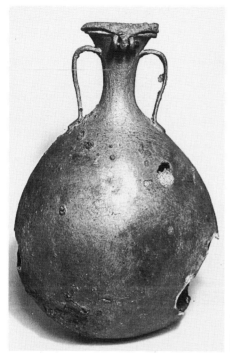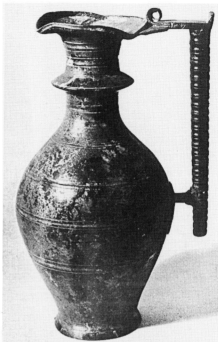

Left: *The Abydos bottle from Egypt, c.1450 BC; the earliest piece of pewter holloware to be identified. An analysis of the metal showed that it is tin with 6 per cent lead, 1 per cent copper and some other trace elements.*

Right: *A Roman wine jug of pewter, found in the Fens. The body of the jug has been turned on a form of lathe.*

THE PEWTER ALLOY

Tin in its pure form is too soft a metal for practical domestic use and so small percentages of hardening agents — copper, bismuth, antimony and lead — have been added either individually or in combination to make it more durable. This alloy is known as pewter.

Considering that over many centuries pewter played an important part in the social and economic life of Britain, it is perhaps surprising that today the tankard and the spirit flask are the only objects widely associated with this alloy. But the range of artefacts that have been made in pewter since the fifteenth century is impressive. Domestic items include chargers (up to 33 inches, or 84 cm, in diameter), plates, flagons, tankards, jugs, candlesticks, porrin-gers, saucers, dishes, bowls, basins, soup tureens, vegetable dishes, straining dishes and bowls, carving plates heated by hot water, punchbowls, loving-cups, caudle cups, wine goblets, beakers, babies' bottles and feeding spoons, pepperpots, sugar castors, salts, spoons, teapots, tea caddies, coffee pots, salvers, biscuit barrels, tobacco jars, cigarette boxes, snuffboxes, sandwich boxes, wine funnels, barbers' bowls, inkpots and standishes, jelly and confectionery moulds, hot-water bed-warming pans, chamberpots and measures in all capacities up to one gallon. Pieces for church use include wine flagons, chalices, patens and cruets, as well as organ pipes. Surgical items such as syringes and bleeding bowls were made of pewter and so were pilgrim

badges, money, tokens, toys, whistles, buttons, chimney ornaments, candle moulds and a host of other everyday utensils.

Pewter was introduced as a material in the Near East not long after the beginning of the bronze age, the earliest piece so far identified being from an Egyptian tomb *c.*1450 BC. The constituents of pewter have been carefully defined in Europe for over six hundred years. Controls were probably first introduced in the twelfth century by the town guilds in France, gradually spreading across central Europe, where the alloys would have been determined locally. In the fifteenth century the control of all pewter production in England was granted to the Worshipful Company of Pewterers in London by royal charter of Edward IV. Records kept by the company enable us to know precisely what regulations were laid down and these are believed to be generally comparable with those of the many individual town guilds controlling the craft in Europe.

The Royal Charter of Edward IV, 1473/4, giving the Pewterers' Company control of the craft throughout England. Above is the company's coat of arms.

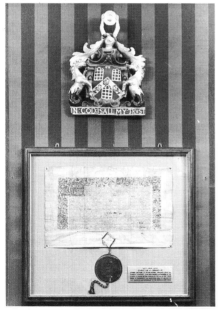

The Worshipful Company originally authorised two grades of pewter, but in the sixteenth century a third standard of alloy was added. For flatware or sadware, as it was described (chargers, plates, dishes, saucers and so on), *Fine* metal was prescribed, consisting of tin with as much copper as it would absorb, which would have been about 1 per cent and certainly not more than 2 per cent. *Trifling metal* or *Trifle* was to be used for holloware (bowls, basins and drinking vessels), made up of fine metal with the addition of about 4 per cent lead. Finally, *Lay* or *Ley* metal, to be used for pieces not in contact with food or drink, was an alloy consisting of tin with the addition of about 15 per cent lead. These alloys remained with only minor variations until well into the twentieth century. Antimony was added as an extra hardening agent to fine metal in the second half of the seventeenth century and the resulting alloy was termed *Superfine Hard Metal* or *French Metal*, but the main changes were that particular pieces were upgraded in alloy so that in more recent times few items would have been made in ley.

Today pewter alloys are just as rigidly controlled, with the constituents being based on the British and European standards allowing for a minimum of 90 per cent tin with the balance being made up of copper, antimony and perhaps a little bismuth. The main difference from the seventeenth-century ordinances is that the addition of lead is not now permitted, the maximum allowable level being fixed at 0.5 per cent — in practice far less — which could be present as a trace element.

A typical casting alloy used today in Europe would be 94 per cent tin, 1 per cent copper and 5 per cent antimony. Pewter sheet, which is also used to form pewter pieces, is a slightly different alloy, generally 92 per cent tin, 2 per cent copper and 6 per cent antimony. In the Far East, particularly Malaysia, Singapore and Thailand, where pewter is widely produced, the alloy usually contains a higher percentage of tin — 97.5 per cent tin, 1 per cent copper and 1¹/₂ per cent antimony, which is a slightly softer material than the alloys predominantly used in Europe.

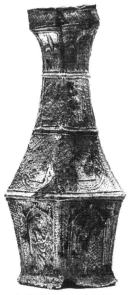

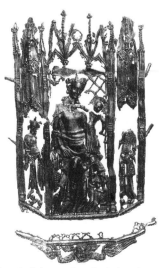

Left: *A fourteenth-century cruet for wine or water, with highly detailed decoration depicting the Virgin Mary and a number of saints; height 5 inches (127 mm).*

Centre: *A pilgrim's pewter ampulla (bottle), late thirteenth century.*

Right: *A pilgrim badge of the Virgin and Child, c.1350-1400. Some pilgrim badges were of remarkably intricate and detailed design. This badge would have been worn with a coloured backing to highlight the openwork design.*

HISTORY OF PEWTER IN ENGLAND

Pewter was introduced into Britain by the Romans at the beginning of the third century AD, or possibly even earlier, and appears to have been produced at a number of sites across the southern half of the country. The quality of the pieces found varies greatly but shows its widespread use as domestic ware. The best Romano-British pewter, however, contains very high levels of tin and there is evidence that some pieces were turned on a form of lathe. This too would indicate the likelihood of a number of manufacturing sites working independently.

Little is known of the craft after the departure of the Romans, the only evidence of its continued existence being a number of brooches and rings of the eleventh century in the Guildhall Museum, London. Norman ecclesiastical records indicate that chalices, patens and cruets were made of pewter at certain periods when the parishes could not afford silver or gold. The number of pewter sepulchral chalices and patens that survive suggests that these were made in considerable numbers, but it would seem that pewter made during the hundred years after the Norman conquest was almost entirely for ecclesiastical use.

By the thirteenth century pilgrim badges of remarkably intricate designs were being made in large quantities for the many pilgrims journeying to Canterbury, Walsingham and other shrines, some being made of pure tin, some of pewter and some of lead.

The records of the craft guilds confirm that domestic ware was being widely produced in pewter from the beginning of the fourteenth century, with their rolls increasingly describing craftsmen specifically as pewterers. Pewter manufacture grew rapidly from this time, with London as the major centre, followed by York, Bristol and Coventry, although it is clear that by the end of the fourteenth century most provincial market towns would have included at least one pewterer in their craft guild.

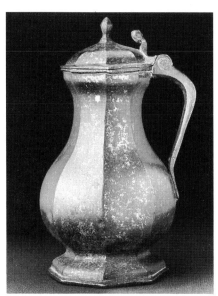

Octagonal flagon, late fourteenth century. Although flagons of this type were originally considered to be by continental makers, it is now thought that they were also made in England. Fabricated from eight separate panels of pewter sheet and referred to as 'square' flagons in the Pewterers' Company records, they were made by flatware makers rather than holloware makers.

The first evidence of the pewterers of London banding together as a 'fraternity' comes from an ordinance covering the composition of alloys to be used and rules for employing freemen, approved by the city authorities in 1348. As a result of the growing importance of pewter to the economy of England — indeed, for a period in the fifteenth century pewter was second only to cloth as England's major manufactured export — the London pewterers were granted or 'purchased' a royal charter from Edward IV in 1474 for the legal control of pewter manufacture throughout England. The charter provided the Worshipful Company of Pewterers, as it became known, with wide authority including the right of entry of pewterers' premises and the power to confiscate sub-standard ware and impose fines on offending pewterers. Searches (inspections of pewter makers) by officers of the Company were carried out regularly from this time, ranging as far north as Northumberland and west into Devon, despite the difficulties and hardships of travel in those days. They confirm the determination of the Company fully to implement its newfound authority and also show how widely distributed pewter manufacture had become.

New ordinances or regulations issued by the Company were detailed and wide-ranging. In addition to the introduction of standard alloys, they laid down manufacturing instructions. For instance, the booges of plates (the booge is the radiused section between the base and the rim) were to be hammered; the reason for this requirement is not clear, but perhaps it reduced the tendency of the rim to crack where it joins the top of the booge, which is an obvious point of stress. The sizes, weights and even the selling prices for a wide range of items then in production were prescribed. The working conditions for a journeyman, a skilled pewterer working for a master, were also defined, as were rules for the training of apprentices and the numbers that could be introduced into the 'mystery', as the trade was often described.

In order to check the level of lead that might be included in an alloy the Company inspectors took with them on their searches an assay mould which was dipped into the craftsman's melting pot. The resulting casting was weighed against the relevant Company standard carried by the inspectors: if it was found to be heavier, it indicated that lead above the prescribed limit

The hammered booge on a wavy-edged plate by Thomas Chamberlain, c.1740. The plate was placed on an anvil and hammered on the inside of the booge. The inside of the plate was then turned and burnished on a lathe to remove the hammer marks.

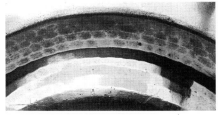

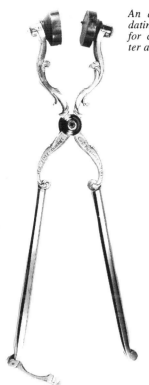

An assay mould, dating from 1728, for checking pewter alloys.

and yet to be identified with a known maker, are also illustrated.

Many flatware pieces of the seventeenth and eighteenth centuries also include pewterers' hallmarks very similar to those of the silversmith, but without the advantage of a date code. In spite of the difficulties of inspection, it would seem that the Company's controls were effective, as in an analysis of a wide range of antique pieces virtually all have been found to be within the required specification. However, many antique pieces bear no maker's mark.

As a result of the Company's efforts to ensure consistent quality throughout the country English pewter became highly regarded on the continent and one sixteenth-century Italian writer stated: 'English pewterers make vessels as brilliant as if they were fine silver and these are held in great estimation.' The craft probably reached its zenith in the second half of the seventeenth century, when it is estimated that some three thousand people were employed in pewter manufacture, four hundred of them

was included. The assay pellet is very small so that the weighing scales, even as early as the sixteenth century, must have been extremely precise.

By act of Parliament in 1503, all pewterers were required to strike their maker's mark on their wares to ensure that the source of manufacture could be identified when checks were carried out at local fairs. The London pewterers in particular also had to record their marks on thick flat plates of pewter kept at Pewterers' Hall. Five plates dating from 1668, the year after the Great Fire, recording the touchmarks, as they were termed, of over 1100 pewterers, have survived and are still retained at Pewterers' Hall. In his book *Old Pewter — Its Makers and Marks*, H. H. Cotterell records the names of over five thousand pewterers. Many of them are listed with the marks they stamped on their pewterware. A large number of marks found on antique pewter,

One of five touchplates at Pewterers' Hall recording the marks of over 1100 pewterers. This one dates from 1668.

7

in London, producing about 3000 tons of pewter annually. It is thought that 30,000 tons of pewterware was in use at any one time during the seventeenth century. A cross-section of typical items in domestic use is likely to amount to some three thousand pieces to the ton. With the population only one-tenth of today's level, this indicates the near monopoly the pewterers must have enjoyed in the provision of domestic utensils generally. Practically every household must have included pewter among its possessions.

BEWDLEY: FACTORY PRODUCTION

Up to the beginning of the eighteenth century there had been little change in the main pewter-manufacturing centres in England, although to some extent Wigan had replaced York as the major northern producer, but, with increasing competition in the domestic field from porcelain, brass and tinplate, pewter manufacture entered into a long period of decline. As a result, the Worshipful Company could no longer sustain its control outside London and at this time a new manufacturing centre emerged at Bewdley, Worcestershire, where the experience gained in the industrial revolution, then in progress, made the area more capable of meeting this new competition. It was not the techniques of manufacture that changed greatly but the structure of the companies making pewter. Hitherto the

trade had been run purely as a cottage industry, with many masters employing just one or two journeymen and perhaps an apprentice. The few new companies in Bewdley were much larger, the most progressive of them employing perhaps thirty people, so providing the opportunity to introduce basic production-line techniques and to some extent to counter the new competition from other materials. It was in Bewdley that for the first time both flatware and holloware began to be produced by the same firm; manufacturers had previously confined their products to a single type of ware. Raw castings were also produced in Bewdley and sold for completion to country pewterers who would have appended their own mark to the piece. Bewdley now became the main centre for pewter manufacture: in any random selection of eighteenth- and nineteenth-century cast pewter, 50 per cent is likely to have been produced there.

DEVELOPMENTS IN STYLE

Until the end of the eighteenth century pewtersmiths in England had devoted themselves almost entirely to the production of domestic pieces and only on very rare occasions did they produce pieces that were solely decorative. This contrasts with the continent of Europe, where many presentation and ceremonial pieces in highly decorated style have survived, but none-

A selection of English domestic pewter, mainly of the seventeenth and eighteenth centuries.

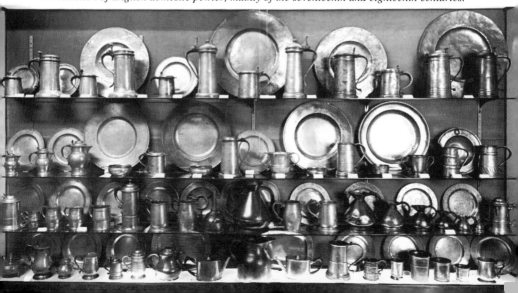

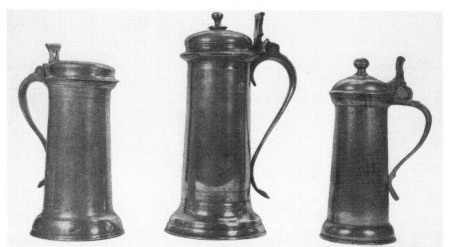

Above: *Two Charles I flagons, c.1630 (left), and a James I flagon, c.1610 (right).*

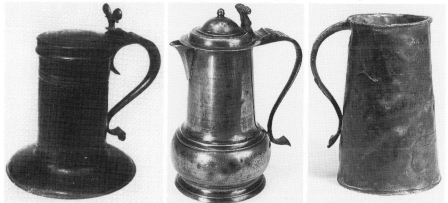

Left: *A Cromwellian lidded flagon with wide splayed base, c.1650.*
Centre: *'Acorn' type lidded York flagon with ramshorn thumbpiece, c.1725. This form of flagon was exclusive to York makers.*
Right: *An inscribed tavern mug, c.1640.*

theless early English pewter with its robust and functional form has great appeal and charm.

Worn or damaged pewter was returned to the pewterer for replacement, so that the purchaser would pay perhaps only one-third of the price of a new piece, but as a result very little pewter from before the seventeenth century has survived. It is therefore difficult to define the changes in design that took place during these early years, but it does seem that forms changed very little from one century to the next. Moulds were expensive to make and, with little competition from other materials, there was perhaps no incentive to incur the expense of creating new forms. However, from the beginning of the seventeenth century clear developments in style are to be found, although these may owe more to the designs of the silversmiths, which were often closely followed by the pewterers. In holloware, the

9

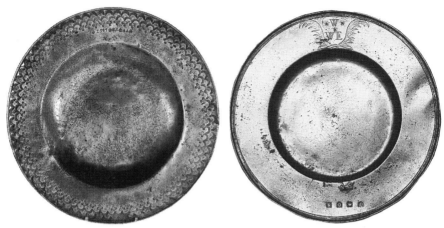

Left: *Broad-rim plate with punched decoration, c.1585.*

Right: *A broad-rim plate with reeded edge, c.1660. Pewterers' Hall marks (here visible at the bottom of the plate, inverted) are often found on the front of plate rims, with the pewterer's main touchmark stamped on the back.*

rather plain design of the James I flagon developed into the more attractive form of Charles I with 'S' handle, bun lid and flared base. Cromwellian flagons show a smoother form with flatter lids and, on occasion, exaggerated flared bases.

In the eighteenth century domed and spire-shaped lids appeared, with perhaps beading on the body and a variety of more complex forms of thumbpiece. Two in-

dividual forms of flagon unique to York makers were produced, a rare example of regional designs emerging. Lidded tankards and tavern pots also showed parallel development into forms showing greater attention to 'style'. Plates went through a number of changes in form during the seventeenth century, from plain-rimmed large-radius booges and 'dome' bottoms in the sixteenth and early seventeenth cen-

Part of a garnish of wavy-edge plates by Thomas Chamberlain, c.1740.

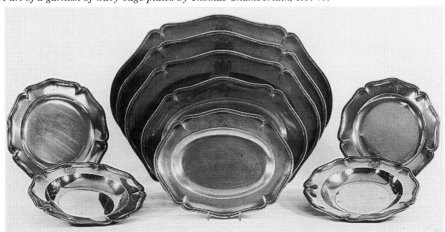

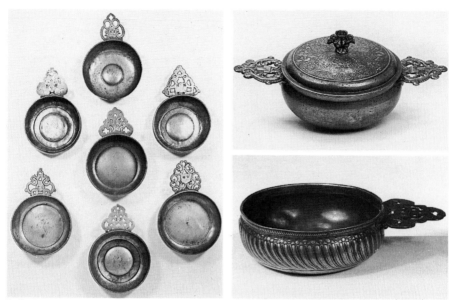

Left: *A group of seventeenth-century porringers, showing a variety of ear designs.*
Right: *Two porringers: (above) lidded porringer with cast decoration, c.1700; (below) porringer with gadroon decoration, c.1710.*

turies to smaller-radius booges, flat bottoms, narrow and broad rims with a variety of forms of 'reeding' (mouldings) on the outer edge. Porringers evolved from plain saucer shapes with trefoil ears (handles) to bulbous forms with complex fretted ears. Similarly, candlesticks in the Stuart period developed from the simple 'bell' form to the very attractive baluster stems, often with wide octagonal bases. Decoration also

Seventeenth-century (Stuart) candlesticks. Large drip trays are often a feature of early pewter candlesticks.

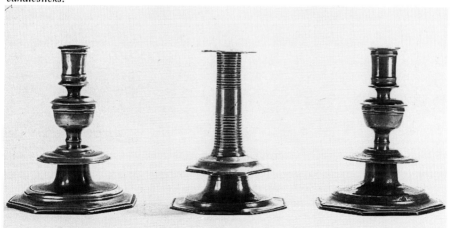

11

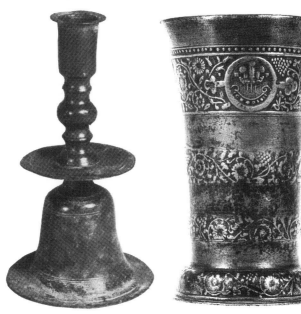

Far left: *Bell candlestick, c.1550-1600.*

Left: *Beaker with cast decoration, c.1610. Cast decoration is a rare feature on English pewter. This beaker commemorates Henry, Prince of Wales, eldest son of James I.*

made a brief appearance during the seventeenth century, although it was very limited and rare in comparison with the plainer forms. Cast decoration appeared on some goblets, beakers and wine cups. Chargers, plates and covered tankards were on occasion decorated with what is termed *wrigglework* engraving, produced by rocking a small chisel-shaped tool across the surface, providing a zigzag outline of the image.

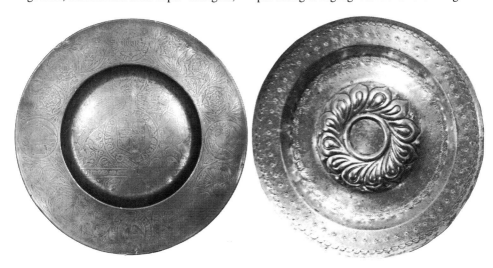

Left: *Charles II charger, c.1660. Very elaborate and well executed wrigglework engraving is found on large chargers celebrating the restoration of the monarchy.*

Right: *George II alms dish, c.1730. Chased or repoussé work on antique English pewter is extremely rare and although this plate was made in England it is considered possible that the repoussé decoration was executed on the continent.*

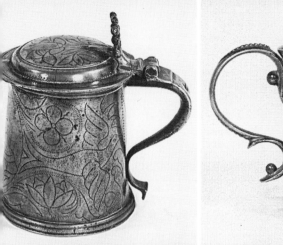
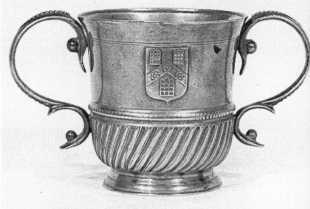

Left: *William and Mary lidded tankard with wrigglework decoration and unusual 'chairback' thumbpiece (handle to rear), c.1690.*

Right: *Posset cup with gadroon decoration, c.1700. Gadroon decoration is cast in on pewter, whereas on silver it is chased.*

Some wrigglework is crude in application but some, particularly numbers of chargers that have survived commemorating the restoration of Charles II, are of such precision as to suggest that the work was probably executed by professional engravers. A few rare porringers have cast low-relief embossed decoration and, very occasionally, gadrooned bodies.

An innovation towards the end of the eighteenth century and still found today was the fitting of glass bottoms to some tankards. A number of reasons for this introduction have been suggested, including checking to see if the King's shilling had been slipped in by the navy press gang, but it is more likely that pewterers had to react to competition from glassmakers, whose tankards allowed the customer to see how clear his beer was.

The reasons for these dramatic changes

Two footed plates, c.1740 (below), and a strawberry dish, c.1755.

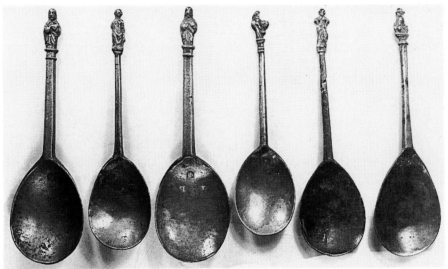

Apostle spoons, c.1600.

in style during the seventeenth and eighteenth centuries are uncertain. It may be that complex moulds became easier to produce or that increased competition forced the pewterers to make their designs more attractive to the consumer. Whatever the reason, the results have provided a wealth of interest to the dedicated collector.

SHEFFIELD: BRITANNIA METAL

Until the last quarter of the eighteenth century all pewterware had been cast and usually turned on a lathe using techniques basically similar to those originally introduced by the Romans. In about 1775 a process was developed in Sheffield for cold-rolling pewter sheet from cast ingots,

Left and right: *The trade cards of Edward Quick and Robert Peircy, c.1725-40.*

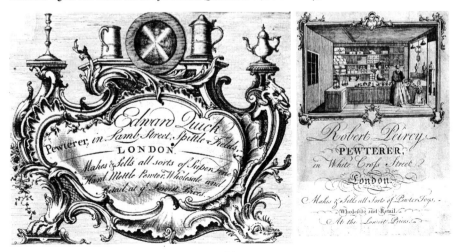

14

the alloy being very similar to superfine hard metal. The availability of sheet allowed pieces to be fabricated in very much the same way as that in which Sheffield plate ware was already being made in the city. (Sheffield plate is a bimetal of silver sheet, rolled and bonded on to a copper sheet base.) The pewter sheet was pressed between metal forming dies or hand-raised with a hammer and the formed parts were soldered together to make the complete piece. This technique freed the pewterer from the constraints of casting and turning on a lathe and resulted in an enormous range of new designs being produced, some in complex chased forms. With the introduction in about 1820 of *spinning*, a technique for forming sheet round a wooden former, or chuck, whilst spinning at high speed in a lathe, the Sheffield pewterer was well placed to produce all the forms previously the preserve of the caster, and far more economically. With the wealth of decorative designs also available to the public from these new techniques, Sheffield gradually became the centre of pewter manufacture in England.

The casters made no effort to exploit the market for highly decorative pewterware for the developing middle class and their trade continued to contract. The Worshipful Company of Pewterers also refused to acknowledge these new techniques in manufacture and, as a result, their influence over the trade virtually ceased.

Nineteenth-century pewter fabricated from sheet is usually described as *Britannia metalware* and it is often not appreciated that it is a high-grade pewter alloy, the only significant difference being the method of manufacture.

In the third quarter of the nineteenth century, Sheffield and to a lesser extent Birmingham, using similar manufacturing methods, were probably employing more than two thousand pewtersmiths and it is possible that pewter may have reached its greatest ever level of production, albeit for a brief period. This trade also enjoyed high levels of export, particularly to the United States. From the middle of the nineteenth century much Britannia ware was silver-plated, denoted by the EPBM mark, but the designs never reached the levels of fine decoration

Left: *Britannia-metal teapot, c.1850, by Broadhead and Atkin of Sheffield; capacity 5 (see caption at top of following page). The body would have been first spun and then formed on a press. Until c.1845 the handles of tea and coffee pots were of wood but after that date they were generally in pewter with an insulated insert to prevent the handle from becoming too hot to hold.*

Right: *Britannia-metal communion flagon, 1844, by James Dixon and Sons, Sheffield.*

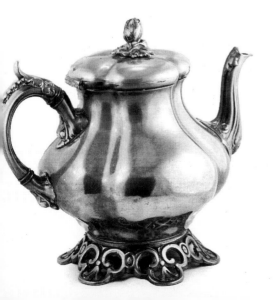
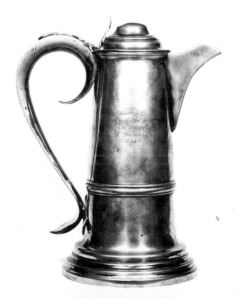

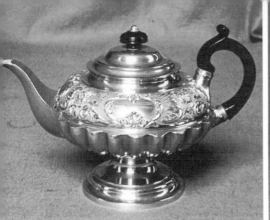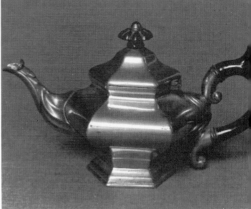

Left: Teapot, c.1829, by Dixon and Son, Sheffield; capacity 5. Nearly all Sheffield-made pieces are marked with the maker's name, together with a design registration number, a capacity number in half pints, ranging from 1 to 8, and sometimes a third number denoting the craftsman.

Right: Bachelor teapot, c.1842, by James Dixon and Sons, Sheffield; capacity 1.

achieved in their unplated counterparts.

In spite of the vast quantities produced in a multitude of designs and styles, Britannia metal has never attracted the serious collector. There is only one reference book on the subject and the ware is little appreciated today though much of it is of high quality and excellent craftsmanship. To be ap-preciated fully, it needs to be thoroughly cleaned and polished, as it was when it first left the factory.

Levels of production declined considerably by the end of the nineteenth century as a result of competition from electro-plated nickel silver (EPNS) and the continuing development of fine porcelain and glassware.

Left: Coffee pot, c.1860, by Shaw and Fisher, Sheffield; capacity 4.

Right: Coffee pot, c.1860, by James Dixon and Sons, Sheffield, capacity 4.

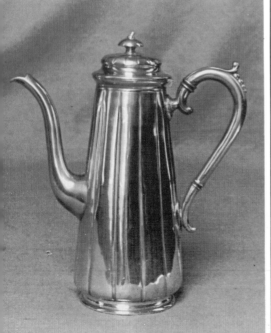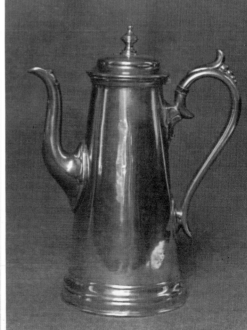

Left: *Tobacco or biscuit box, c.1850, by R. F. Sturges, Birmingham. The box is formed from pewter sheet with rolled flat chased decoration.*

Right: *Self-pouring teapot by James Dixon and Sons of Sheffield, c.1890. The lid is lifted and depressed to dispense tea through the spout.*

THE TWENTIETH CENTURY

Pewter also enjoyed considerable success during the brief Art Nouveau period at the beginning of the twentieth century, as it is a material ideally suited to the styles of ornamentation and flowing designs that became so popular. Although Art Nouveau pewterware was most widely followed and produced in Germany, Liberty's of London commissioned work from leading designers, most notably Archibald Knox and Rex Silver, which gave English Art Nouveau a distinction of its own, being rather more restrained than continental designs. The pieces, both cast and pressed, were produced by Liberty's silversmith company in Birmingham (W. H. Haseler) and are now much collected. Liberty's hold annual

Liberty's Art Nouveau teaset, c.1901, by W. H. Haseler and Company, Birmingham.

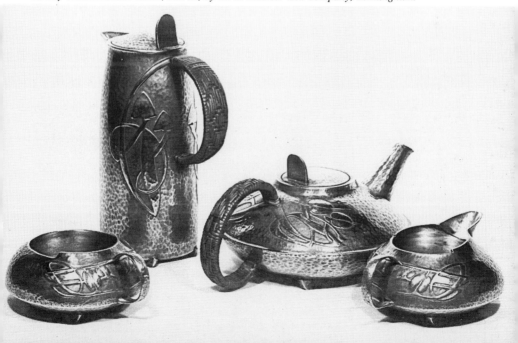

 Quality marks of the Association of British Pewter Craftsmen.

exhibitions of Art Nouveau pewter at their Regent Street store.

There were few developments in the pewter industry between the end of the Art Nouveau period in about 1910 and the end of the Second World War. The new designs of the 1930s from Sheffield and Birmingham lacked confidence and direction. From the beginning of the 1950s a number of factors have combined to create an increasing interest in pewter. White-metal, generally described as a tin/lead alloy, and

pewter costume jewellery had been produced using the centrifugal casting process (described in the following chapter) since the end of the war and this technique was adapted more widely some ten years later, particularly for figurines, where the slight pressure exerted in the process enables intricate detail to be accurately reproduced. Although most pewter manufacturers now employ centrifugal casting to produce the appendages, such as handles, spouts and feet, for their normal products, a number of model makers and individual craftsmen have adopted this technique to create a new market for pewter, producing a wide range of figurines, particularly soldiers, military vehicles and cars, together with quality

A display of modern pewterware.

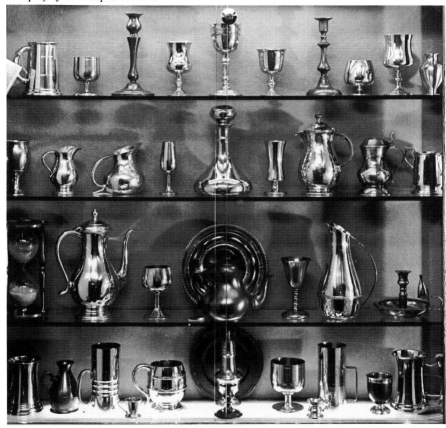

18

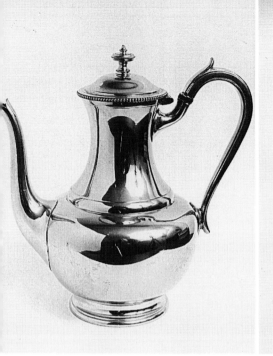

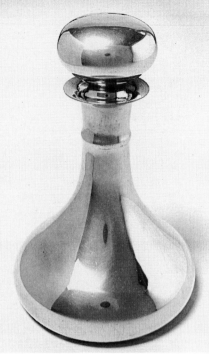

Above left: *Modern coffee pot by James Dixon and Sons of Sheffield.*

Above right: *Modern spun decanter by PMC, Sheffield.*

Below left: *Modern figurine of British soldiers at the time of Waterloo, by Buckingham Pewter. It shows the great detail that can be achieved by centrifugal casting.*

Below right: *A modern spun lidded tankard by James Dixon and Sons.*

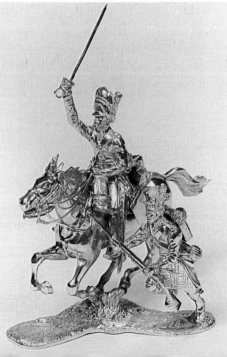

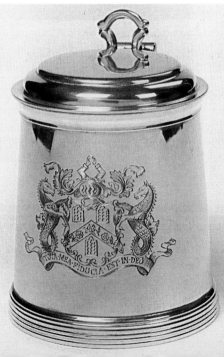

collectables from steam locomotives to thimbles. This giftware market has enjoyed significant growth in recent years, creating a large new outlet for pewter products.

The traditional industry, too, has changed considerably with the appreciation that to compete in the international markets of today it is necessary for the small independent manufacturers to work more closely together. To further this aim, the Association of British Pewter Craftsmen was jointly formed by the manufacturers, the metal suppliers and the Worshipful Company of Pewterers in 1970 with the objective of controlling the quality of the products, providing a centralised information source and creating a greater general awareness of pewter. Standards for metal thickness, grades of solder and finish have been defined, and members are required to add their mark, with that of the Association, to their products. These regulations compare with those introduced by the Pewterers' Company in the sixteenth century.

With the aim of broadening the range of designs of items being made in pewter, the Worshipful Company of Pewterers, in conjunction with members of the Association and other interested parties, sponsors annual design competitions for students at a number of art colleges. Some of the winning designs have been successfully adapted by the manufacturers for large-scale production.

With the formation of the European Common Market, many of the national pewter associations have joined together to form the European Pewter Union with the objective of providing common standards for pewter manufacture throughout Europe.

An indication of the growing appreciation of pewter is the increasing number of special commissions placed with the trade and individual craftsmen. With the high cost of silver, pewter can be regarded as a very suitable alternative, being capable of forming by similar techniques and given, if

Left: *A candlestick with cast applied decoration by Edwin Blyde Limited, Sheffield.*

Centre: *A beadle's staff head by Hull Pewter.*

Right: *Flower vase by I. Gibson and Sons, Sheffield, 1990; height 15 inches (381 mm).*

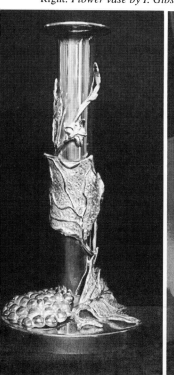
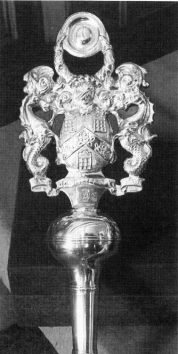
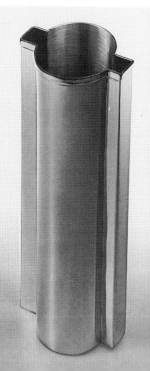

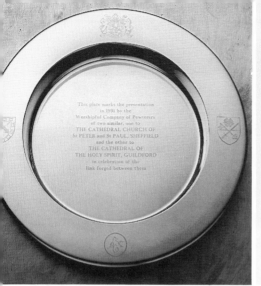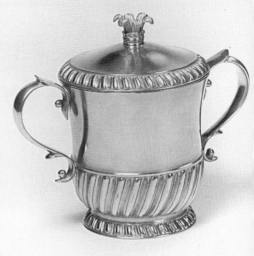

Left: *A replica of collection plates presented to Sheffield and Guildford cathedrals in 1991; made by A. R. Wentworth and Company, Sheffield.*

Right: *A cast covered posset cup in Queen Anne style by Hull Pewter.*

desired, a finish almost indistinguishable from silver. The church in particular has taken advantage of this potential and church plate ranging from altar sets, candlesticks and collection plates to furniture inlay has begun to appear in pewter.

The long history of pewter in England has tended to restrict designs of present-day pewter largely to reproductions of antique forms, although new designers are starting to explore the potential of the metal with truly modern designs.

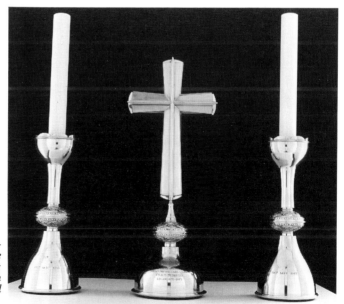

Altar cross and candle-sticks for Pembroke College, Cambridge; designed by Keith Redfern, 1986, and made by Tom Neal.

21

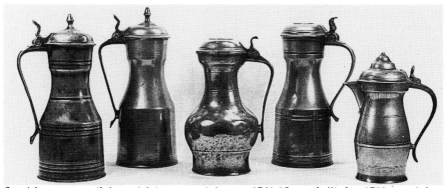

Scottish measures: (left to right) two tappit-hens, c.1760-85; pot-bellied, c.1700; tappit-hen, c.1760-85; unusual wine measure, c.1795.

PEWTER AROUND THE WORLD

SCOTLAND

The manufacture of pewterware in Scotland developed entirely independently from England. As in the rest of Europe, tradesmen set up their own guilds to control the trade of their members. The pewterers were included as members of the 'Incorporation of Hammermen' which would have existed in each of the major towns from the end of the fifteenth century, along with blacksmiths, armourers, cutlers and perhaps some other trades where hammering was an important feature.

Because of the different social conditions in Scotland, the pewterers never achieved dominance in the production of domestic ware in the sixteenth and seventeenth centuries as they did in England, and antique Scottish pewter is even rarer than English. What pewter has survived shows more similarity in form to pewter from France and the Low Countries, perhaps because of the close trading ties that existed. The most widely known Scottish pieces are measures, particularly the tappit-hen with its very striking form of tapered top and bottom sections joined by a concave centre section.

Tankards or tavern pots in a number of different forms were produced during the nineteenth century with the main centres of manufacture being Edinburgh and Glasgow. Numerous ecclesiastical pieces have also survived, mainly dating from the late eighteenth or nineteenth centuries. A particularly attractive design of communion flagon, straight-sided with tapering base and slightly domed flat lid, is recognised as a distinctive Scottish form.

Scottish pewter is always of good quality although unfortunately it does not bear the maker's mark as often as its antique English counterparts. Scottish pewterers were required to strike their wares with the maker's mark, although this procedure does not appear to have been rigidly enforced. However, two Edinburgh touch plates have survived and are now in the possession of the Royal Museum of Scotland in Edinburgh.

IRELAND

Pewter has been made in Ireland since the seventeenth century, and possibly considerably longer as some abbey records refer to pewter in their inventories. As in Scotland, antique pewter is extremely rare although chalices and church flagons do survive, with some distinct characteristics which suggest that they were probably made locally rather than imported from England.

Measures were certainly made in Ireland, the most notable being the Irish 'haystack' of the early nineteenth century, which is still being produced today. Another well known Irish measure is the 'hoggin', which is of beaker form with slightly convex body and flared base and lip.

WALES

It had been thought that no pewter was indigenous to Wales but recent research has indicated the likelihood of pewter having been manufactured at least in some Welsh market towns near the border. As yet, no styles in pewterware have been identified that can be directly related to Welsh manufacture.

MAINLAND EUROPE

Pewter may have been introduced into Europe by the Romans although there is no clear evidence to confirm this.

In the middle ages pewter manufacture appears to have developed at a rather earlier date than in England. The structure of control, however, was different in that the local town guilds set their own individual standards. Whilst this does not provide an absolutely consistent quality, it does give a far wider range of regional designs and styles than are to be found in England. Notable centres of production in France were located at Paris, Bordeaux and Lyons, and in Germany at Nuremberg and Munich, but, as in England, by the sixteenth

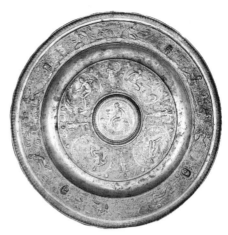

Temperance charger by François Briot, 1590.

century every market town is likely to have had its own pewtersmith. Flanders, Holland, Switzerland, Austria and Italy were also producing pewter, again in their own distinctive national forms.

Although plain functional designs were used for purely domestic utensils, contin-

Irish lidless measures with a 'haystack' of 1 gallon capacity, c.1830.

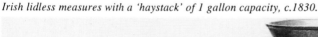

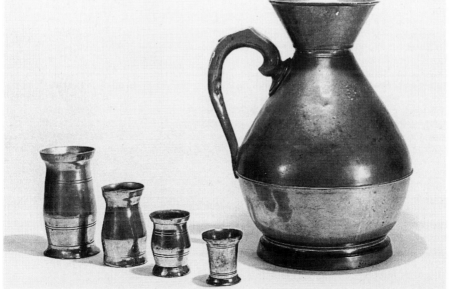

23

ental pewter is much more prone to decoration, particularly cast embossed work. The development of these highly decorated pieces is credited, at least partly, to the forced emigration of Huguenots from France in the sixteenth and seventeenth centuries, and although these designs may seem over-fussy and ornate to someone used to the plain functional shapes of English pewter it is impossible not to admire the supreme skill of early continental mould makers. A number of Huguenot pewterers are known to have come to England, the most notable being Jacques Taudin, who is credited with introducing antimony into the alloy as a hardening agent in the latter half of the seventeenth century. No English styles in pewter can be directly attributed to their influence, as can be seen with contemporary silversmith immigrants.

Pewter made from sheet has never been developed as in England, and European pewter is still predominantly made by casting into metal or sand moulds.

THE UNITED STATES

In North America pewter manufacture began much later than in Europe and initially all pewter was imported from Europe, particularly England. Early American pewterers also suffered the enormous disadvantage of a prohibition on the import of unfashioned tin, so that to make up for this deficiency in material they were forced to add higher levels of lead than would have been acceptable across the Atlantic.

Their designs tended to follow the English styles closely, but perhaps fifty years later. There was also influence from Dutch and German immigrants, giving some pieces a distinctly continental form, although without the decoration. The quality of the surviving pieces is excellent, with some outstanding makers well up to the standards of their European counterparts.

Britannia metalware was also produced from about the 1830s. It, too, is of high quality, the designs being generally less complicated in form than in England. Most

Left: *Early eighteenth-century French cimarre, or footed flagon.*
Right: *German guild flagons of the seventeenth and eighteenth centuries.*

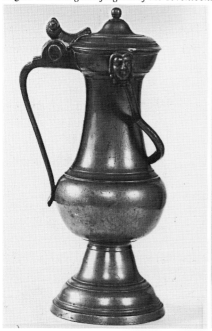
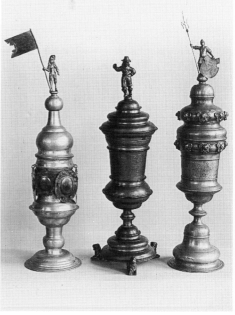

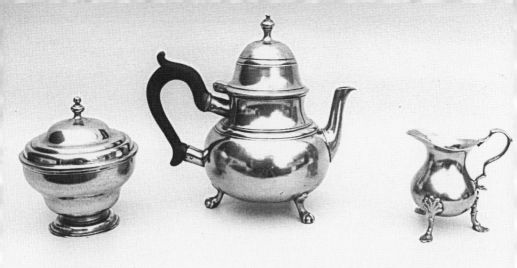

American pewter: sugar bowl, teapot and creamer by William Will, late eighteenth century.

modern American pewter is made from sheet with designs strongly following the traditional shapes of the past.

The United States also has a number of skilled individual craftsmen working in pewter, who have produced many outstanding pieces of modern design.

ASIA AND ELSEWHERE

Pewter was introduced into Malaysia from China at the beginning of the twentieth century. Initially the techniques used were simple, oriental pewter being hand-formed from cast pewter sheet with most pieces having some religious significance.

The craft in Malaysia, Singapore and Thailand has developed dramatically since the 1950s, with the pewterers adopting European techniques of casting into metal moulds and finishing on a lathe. Designs of great variety are now produced, both for traditional pieces and also in European forms, to an excellent quality and finish, using well equipped modern workshops.

Japan, Brazil and Indonesia also have skilled craftsmen working in pewter and today pewter is produced in some form in most countries of the world.

Malaysian pewter: a coffee pot being given a final finish by rubbing with a 'stone' leaf, found locally, at the Selangor Pewter Company, Kuala Lumpur. This treatment is common practice for Far Eastern pewter.

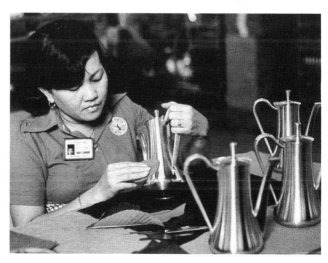

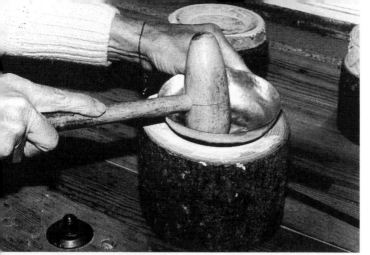

Hand-raising a pewter bowl.

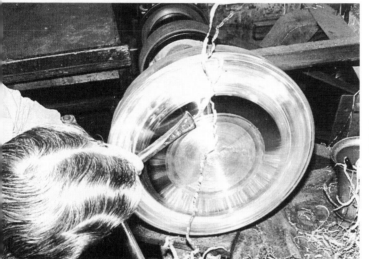

Turning a large cast plate using wood-turning techniques.

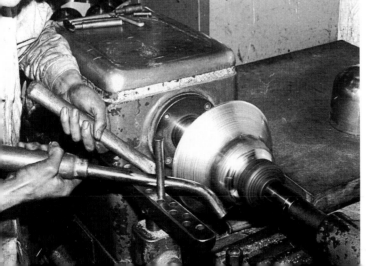

Spinning, using a hooked tool and back stick. A lubricant of grease, soap and oil compounds is used to prevent the pewter picking up on the tool.

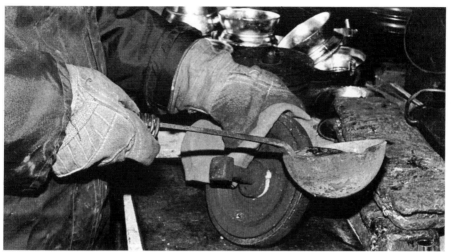

Casting pewter into a metal mould.

THE TECHNIQUES OF PEWTER WORKING

Pewter is an extremely adaptable and versatile material capable of being formed by a number of different processes. Apart from in England and the United States, most pewter is still produced by casting, the technique originally introduced by the Romans. Some Roman limestone moulds have survived but there is no evidence of their using metal moulds.

GRAVITY CASTING

From the thirteenth century most moulds were made of bronze although as late as the fifteenth century soapstone (steatite) moulds were also used for small items such as pilgrim badges. The techniques of bronze casting had long been established and the metal is ideally suited to the needs of the pewterer with its good heat transfer — cooling quickly in normal atmosphere — and is extremely durable. Some English pewterers are still using bronze moulds that have been in regular use for well over a hundred years. Today, with the improvements in machining facilities, steel moulds are more generally used, although the principles of casting are exactly the same. Iron or aluminium moulds are also sometimes used.

In gravity casting the molten metal is poured into the top of the mould, which fills through normal gravitational force.

Moulds are often made up of several parts which, when assembled, will provide a wall to the casting about $1/8$ inch (3 mm) thick, of the approximate shape of the finished piece. Before assembly, the surfaces of the mould are coated with a release agent, either red ochre (iron oxide) and white of egg with perhaps a little pumice powder (the old traditional formula), or graphite powder, to prevent the cast sticking to the mould. Pewter is heated in a ladle to an average of 300-350°C (570-660°F); pewter melts at 238°C (460°F). The mould is assembled and preheated, usually by making a number of trial casts until the correct temperature is reached. The metal is then poured carefully into the mould, making sure that no air is trapped, sometimes by rotating the mould through 90 degrees during pouring.

Most cast pewterware is made up from several separate castings which are soldered together and then turned on a lathe, using wood-turning techniques, with perhaps the final finish being achieved by rubbing with a dampened 'Scotchbrite' pad

whilst still turning on the lathe. Finally handles, spouts and feet are soldered on to complete the piece.

Sand casting of pewter is still widely used in Europe, particularly Belgium and Italy. Sand moulds are formed using wooden patterns and the procedures follow closely those employed in bronze, aluminium and iron foundries. The resulting castings are generally finished by turning on a lathe, as with castings made in metal moulds. For reproduction of old designs, sand castings are sometimes finished using buffing and polishing techniques only, as this will tend to give the pewter the slightly worn and 'used' appearance of an antique piece.

PRESS FORMING

Pewter sheet can be formed in a hand (fly) or hydraulic press. The sheet is pressed between steel or in some cases plastic dies (formers) suitably patterned and contoured to the top and bottom shape required. Sheet can also be formed by the use of a drop stamp, where a heavy steel die is dropped from a height of 10 to 12 feet (3.0 to 3.7 metres) on to a pewter sheet resting on a block of lead. These techniques were widely used in the nineteenth century in the production of Britannia metalware. Again, formed pieces are soldered together to complete.

A sand-casting mould box complete with a casting of a flagon body, showing the large risers. The wooden pattern is on the left.

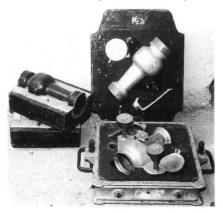

SPINNING

Spinning, perhaps the most skilled of all pewter forming techniques, is carried out by smoothing a pewter sheet disc over a wooden or nylon former, referred to as a chuck, using a polished steel burnishing tool whilst spinning at high speed in a lathe. Great sensitivity or 'feel' is required to avoid crinkling the metal and to ensure that constant thickness is maintained, regardless of the complexity of form. Highly experienced spinners can form the metal on 'air', that is without the use of a chuck to control the shape, employing a back stick in conjunction with the burnisher to create the required form. Pewter is unusual in that unlike other metals it does not work-harden. It is therefore not necessary to anneal, to restore to original condition by heating, during the forming process. Separate pieces are soldered together as in the other processes. The high polish on most spun pewterware is achieved by polishing on a buffing wheel.

CENTRIFUGAL CASTING

Centrifugal casting is particularly suitable for small castings, such as figurines, where great detail is required.

Moulds are formed by vulcanising uncured rubber, either silicone or nitrile, round a 'master' usually made of brass. Temperature during vulcanising is about 160°C (320°F) so that the master must be capable of standing this heat at least. After curing, the master is removed, leaving an exact replica of its form in the rubber.

Moulds can also be made from cold-cure silicone rubber. They are equally effective although rather less durable.

The mould is spun in the machine at a speed between 500 and 1000 revolutions per minute, depending on the size and form of the casting, and molten metal at about 300°C (570°F) is poured into the central infeed. The centrifugal action of the spinning forces the pewter into the mould cavities, in effect giving a low-pressure casting. Very intricate and detailed castings, which require the minimum of finishing, can be achieved in this way.

Present equipment limits the size of individual castings, but because of the great

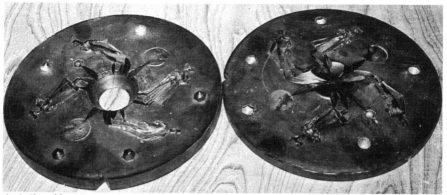

A nitrile rubber figurine mould for a centrifugal casting machine.

popularity of small giftware items centrifugally cast objects provide a significant proportion of the pewter being produced today.

SOLDERING

Soldering of pewter requires considerable skill and delicacy as solder melts at a temperature only slightly lower than pewter.

Until blow-torches were introduced at the beginning of the seventeenth century soldering irons would have been used, although a method of joining pieces together known as 'burning on' was also employed. This method involved fixing a mould to an already finished piece and casting a new piece on to it, which resulted in a form of welded joint. Many antique porringers had their ears fixed in this way. Although very neat and strong, this method is not used today as it is a difficult and lengthy process.

Solders are usually a tin/lead or lead-free alloy containing bismuth, although occasionally pure tin is used as in the vertical seam on a spun tapered tankard or flask. To ensure a good soldered joint, a wetting agent, or flux, is required to prevent oxidation of the joint when heated. A number of liquid or paste fluxes are suitable although most pewterers prefer a solution of one part hydrochloric acid and ten parts glycerine, which greatly assists the solder to flow along the joint.

A gas/air blow-torch with a narrow needle-point flame is usually used, as this can be accurately directed on to the joint and the heat confined to the area where it is needed. Butane gas torches are also suitable, although slightly more difficult to control because of the hotter flame. Soldering irons can be used, but great care is required as the iron is likely to be at a temperature above the melting point of pewter.

Good soldered joints are virtually indistinguishable from the parent metal.

FINISHES

Pewter is adaptable to a number of different finishes ranging from a bright satin, often preferred by the traditional casters, to highly polished, generally chosen by the spinners. Hammered finishes are also popular on pewter, produced either by hand hammering over a former or by passing sheet through dimpled rollers before fabrication. An 'antique' appearance can be achieved by dipping the finished piece into a solution of nitric acid and then lightly buffing to produce highlights.

The Japanese have developed a method of dyeing pewter in a range of pastel shades which, when engraved, produce an attractive contrast.

Chasing and repoussé techniques can also be used to embellish pewter designs and have been widely employed over the years, particularly in nineteenth-century Britannia ware, made from pewter sheet.

Pewter, unlike silver plate, is very suitable for hand and machine engraving, resulting in its great popularity today for sporting trophies.

29

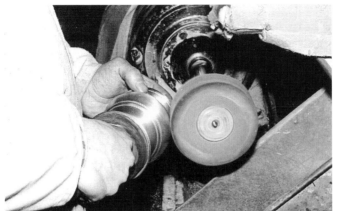

Polishing, using a buffing wheel.

Applying chased decoration.

Engraved pewter with a range of engraving tools.

COLLECTING PEWTER

Pewter tarnishes far more slowly than silver or copper and for a new piece, kept in a relatively dry atmosphere, the only cleaning necessary is to wash in a mild detergent and dry with a soft cloth perhaps once a year. Pewter in a slightly dirtier condition will be restored by a good metal polish.

The cleaning of antique pewter depends on personal preference. Many collectors like to leave the patina on their pewter, while others may wish to restore its original appearance by removing the hard oxide that may be present. This cannot be done with metal polish but hard oxide can be removed using a solution of caustic soda — 3 to 4 ounces to a gallon of water (18-25 grams per litre). Acid cleaners should not be considered as these can cause further corrosion over the years, being very hard to remove completely after application.

Dents can usually be removed by using a wooden mallet or lead-faced hammer suitably shaped. Solder repairs should be done only by a professional restorer or an experienced metalworker.

Because so much old pewter was melted down for replacement, antique pewter is extremely rare, in spite of the vast quantities that were originally produced. Seventeenth- and eighteenth-century pewter commands high prices at auction and is a very specialised collectors' market. However, for those more interested in form than lineage, it is still possible to find at reasonable prices attractive nineteenth-century Britannia metal pewter which, once cleaned, will give lasting pleasure.

FURTHER INFORMATION

BOOKS
Brett, V. *Phaidon Guide to Pewter*. Phaidon, 1981.
Charon, S. *Modern Pewter Design and Techniques*. David & Charles, 1973.
Cotterell, H. H. *Old Pewter – Its Makers and Marks*. Batsford, 1929.
Cotterell, H. H.; Riff, A.; and Vetter, R. M. *National Types of Old Pewter*. Pyne Press, reprinted 1972.
Hall, D. W. *Irish Pewter – A History*. The Pewter Society, 1995.
Hatcher, J., and Barker, T. C. *A History of British Pewter*. Longman, 1974.
Homer, R. F., and Hall, D. W. *Provincial Pewterers*. Phillimore, 1985.
Hornsby, P. R. G. *Pewter of the Western World 1600-1850*. Schiffer Publishing Ltd, 1983.
Hornsby, P.; Weinstein, R.; and Homer, R. *Pewter, a Celebration of the Craft 1200-1700*. Museum of London, 1989.
Hull, C. J. M., and Murrell, J. A. *The Techniques of Pewtersmithing*. Batsford, 1984.
Kauffman, H. J. *The American Pewterer*. Thomas Nelson, 1970.
Levy, M. *Liberty Style*. Weidenfeld & Nicolson, 1986.
Martin, S. A. *Archibald Knox*. Academy Editions, 1995.
Montgomery, C. F. *A History of American Pewter*. Winterthur Museum, 1973.
Moulson, D., and Neish, A. *An Introduction to British Pewter Illustrated from the Neish Collection at the Museum of British Pewter*. Brewin Books, 1997.
Peal, C. A. *Let's Collect British Pewter*. Jarrold, 1977.
Peal, C. A. *Pewter of Great Britain*. John Gifford, 1983.
Scott, J. L. *Pewter Wares from Sheffield*. Antiquary Press, 1980.
Wood, L. Ingelby. *Scottish Pewterware and Pewterers*. A. Morton, 1907.

USEFUL ADDRESSES
Association of British Pewter Craftsmen, Unit 10 First Floor, Edmund Road Business Centre, 135 Edmund Road, Sheffield S2 4ED. Telephone: 0114 252 7550. Website: www.abpcltd.co.uk
Worshipful Company of Pewterers, Pewterers' Hall, Oat Lane, London EC2V 7DE. Telephone: 020 7606 9363. Website: www.pewterers.org.uk

PLACES TO VISIT

Museum displays may be altered and readers are advised to check that relevant items are on show and to find out the opening times before making a special journey.

The American Museum in Britain, Claverton Manor, Bath BA2 7BD. Telephone: 01225 460503. Website: www.americanmuseum.org American pewter.

Arlington Court (National Trust), Arlington, Barnstaple, North Devon EX31 4LP. Telephone: 01271 850296. Website: www.nationaltrust.org.uk

Ashmolean Museum of Art and Archaeology, Beaumont Street, Oxford OX1 2PH. Telephone: 01865 278000. Website: www.ashmol.ox.ac.uk

Bewdley Museum, The Shambles, Load Street, Bewdley, Worcestershire DY12 2AE. Telephone: 01299 403573. Website: http://bewdleymuseum.tripod.com

Birmingham Museum and Art Gallery, Chamberlain Square, Birmingham B3 3DH. Telephone: 0121 303 2834. Website: www.bmag.org.uk

The Burrell Collection, Pollok Country Park, 2060 Pollokshaws Road, Glasgow G43 1AT. Telephone: 0141 287 2550. Website: www.glasgowmuseums.com

Cheltenham Art Gallery and Museum, Clarence Street, Cheltenham, Gloucestershire GL50 3JT. Telephone: 01242 237431. Website: www.cheltenhammuseum.org.uk

Fitzwilliam Museum, Trumpington Street, Cambridge CB2 1RB. Telephone: 01223 332900. Website: www.fitzmuseum.cam.ac.uk

Holkham Hall, Holkham Estate, Wells-next-the-Sea, Norfolk NR23 1AB. Telephone: 01328 710227.

Kelvingrove Art Gallery and Museum, Argyle Street, Kelvingrove, Glasgow G3 8AG. Telephone: 0141 287 2699. Website: www.glasgowmuseums.com

Millennium Galleries, Arundel Gate, Sheffield S1 2PP. Telephone: 0114 278 2600. Website: www.sheffieldgalleries.org.uk

Museum of British Pewter, Harvard House, High Street, Stratford-upon-Avon, Warwickshire. Telephone: 01789 204507. Website: www.shakespeare.org

Museum of London, London Wall, London EC2Y 5HN. Telephone: 020 7600 3699. Website: www.museumoflondon.org.uk

Preston Hall Museum, Preston Park, Yarm Road, Stockton-on-Tees TS18 3RH. Telephone: 01642 781184.

Smith Art Gallery and Museum, Dumbarton Road, Stirling FK8 2RQ. Telephone: 01786 471917. Website: www.smithartgallery.demon.co.uk

Victoria and Albert Museum, Cromwell Road, South Kensington, London SW7 2RL. Telephone: 020 7942 2000. Website: www.vam.ac.uk

Worshipful Company of Pewterers, Pewterers' Hall, Oat Lane, London EC2V 7DE. Telephone: 020 7 606 9363. By appointment only. Website: www.pewterers.org.uk

York Castle Museum, Eye of York, York YO1 9RY. Telephone: 01904 687687. Website: www.yorkcastlemuseum.org.uk

Modern American pewter.

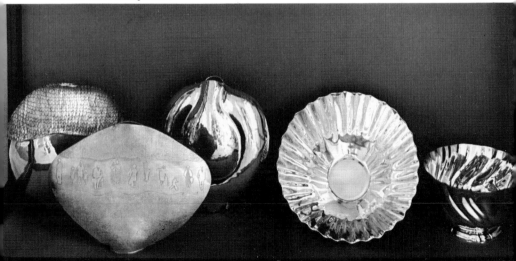